**Enjoy**是欣賞、享受，
以及樂在其中的一種生活態度。

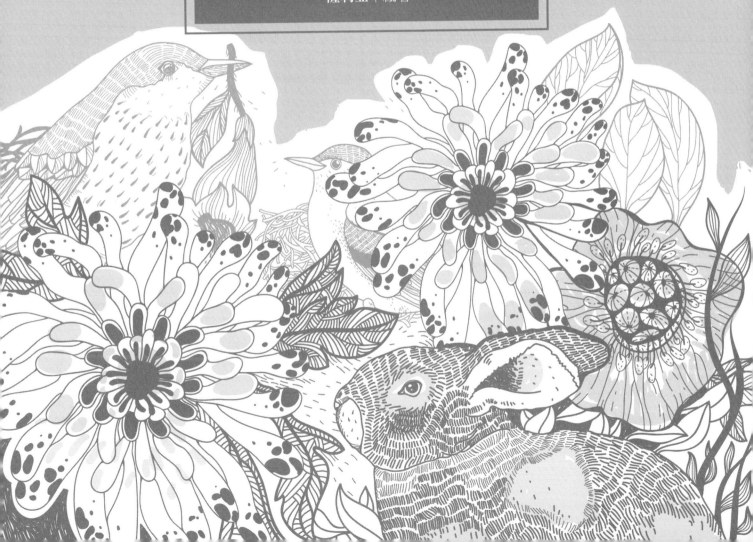

# 華麗的探險

Brighten up your Life

臨摹英文佳句，練字練心，探索自我

薩莉亞｜編著

# 提 筆 吧 ！
# 向自我的探險，最華麗，也最寧靜

當你拿起了這本書，我們相信一定是某種渴求的聲音驅使了你。那是一種想要填補心靈空缺、尋求最真自我的聲音；是一種想要遠離過於喧囂的世界、尋求純粹寧靜的聲音——也是這種聲音，讓我們想為你出版這本書。

從小，我們讀過不少經典英語格言，曾受那些話語激勵，也曾因它而度過低潮，但隨著歲月的匆忙，這些美好佳語也漸漸離開我們的心底，難以將其一一拾回。

這本美麗的手抄書，將讓你重新找回這份被遺忘的悸動。

## | 手抄格言，銘記在心，增強英文力 |

為何以前讀過的英文格言總是容易忘記？那是因為你不曾臨摹抄寫。我們對於優美佳句的記憶，必然發生在抄寫之中。不抄寫，絕對過目即忘。因此臨摹抄寫是引領你銘記英文格言的第一步。而在記憶的當下，你不僅將優美的英文佳句放進心裡，無形中也累增自己的英文力。

## | 依四季，精選格言 |

你會看到，我們依四季的節奏、溫度及心緒，套上了不同的色彩與圖案，成為本書的基調。而在

每頁所精選的格言佳句，皆是依當季的脈動來選擇，無論是春季的喜悅、夏季的激情、或是在秋季的省思、冬季的感恩與期待，都將帶給你心靈不同層次的啟發。

## 細緻的手抄空間，創造欲罷不能的滿足感

此書的開本、字體與字級大小，皆是我們經過不斷嘗試而尋得的黃金比例。試試看，當你要下筆前，先仔細眼觀英文格言，佐以中文翻譯，領略其中意涵，再提筆跟隨虛線臨摹，你將進入一種意隨筆走的暢快境界。至此，你必然感到欲罷不能，而我們也隨後附上無虛線的書寫空間，任你盡情展現個人的英文書寫。

## 走過四季，把最好的祝福送給自己

當你寫完這本手抄書，心裡也已經滿溢著美好的英文格言。這時候，別忘記給自己喝采，寫個卡片祝福自己——是的，你值得擁有這一切美好的讚許。

這本手抄書，必定帶給你意想不到的心靈提升。一段美好的英文格言，如同一幅美好的圖象，跟隨那華麗的草體書寫，每一個小彎曲、小上揚都會引領你的意念進入最寧靜之界。不計晨昏、不計冷暖，任何時候都是你進入此書的最美好時刻。現在就提筆吧！

*Winter*

# 冬 季

## 感恩於心，懷抱期待

休息是為了再甦醒
來年的新綠，也同時蓄勢待發
過往的種種令人深深感謝
是它們，滋養了未來

*1,* Life finds its wealth by the claims of the world, and its worth by the claims of love.

Life finds its wealth by the claims of the world, and its worth by the claims of love.

生命因世界而變得富有，因愛情而變得有價值。 ——泰戈爾

Life finds its wealth by the claims of the world, and its worth by the claims of love.

*2, One word frees us of all the weight and pain of life – that word is love.*

One word frees us of all the weight and pain of life– that word is love.
有個字能將我們從生命的重擔與苦痛中釋放——那個字就是「愛」。
——索福克勒斯（希臘悲劇詩人）

*One word frees us of all the weight and pain of life – that word is love.*

3, *Follow your own course, and let people talk.*

Follow your own course, and let people talk.
走自己的路，隨人家去說吧。——但丁

*Follow your own course, and let people talk.*

*4,* *Learn from the winter trees, the way they kiss and throw away their leaves, then hold their stricken faces in their hands and turn to ice.*

Learn from the winter trees, the way they kiss and throw away their leaves,
then hold their stricken faces in their hands and turn to ice.

跟冬天的樹學習如何親吻後扔掉葉子，然後學習如何用手捧住受傷的臉並變成冰。——凱洛・安・達菲（英國桂冠詩人）

*Learn from the winter trees, the way they kiss and throw away their leaves, then hold their stricken faces in their hands and turn to ice.*

*5, Love the people who treat you right and forget about the ones who don't.*

Love the people who treat you right and forget about the ones who don't.
愛那些對你好的人，忘掉那些不知珍惜的人。──哈維‧麥凱（美國演說家）

*Love the people who treat you right and forget about the ones who don't.*

6, *Life is the sum of all your choices.*

Life is the sum of all your choices.
你生命是你所有選擇的總結。——卡繆

*Life is the sum of all your choices.*

winter

*If you care about what others think
of you, then you will always be their
slave.*

If you care about what others think of you, then you will always be their slave.
總在乎其他人怎麼看你，那你會一直是他人的奴隸。
——詹姆斯‧弗雷（美國作家）

*If you care about what others think of you, then
you will always be their slave.*

*8, Be able to be alone. Lose not the advantage of solitude.*

Be able to be alone. Lose not the advantage of solitude.

**要有單獨自處的能力，不要錯過孤寂的好處。——托馬斯・布朗（英國作家）**

Be able to be alone. Lose not the advantage of solitude.

*9,* *You may be disappointed if you fail,*
*but you are doomed if you don't try.*

You may be disappointed if you fail, but you are doomed if you don't try.

**失敗時你可能會失望，但如果你從不嘗試，將注定失敗。**

**──貝弗利·希爾斯（美國歌唱家）**

*You may be disappointed if you fail, but you*
*are doomed if you don't try.*

*Reflect upon your present blessings, of which every man has many, not on you past misfortunes, of which all men have some.*

Reflect upon your present blessings, of which every man has many,
not on you past misfortunes, of which all men have some.

多想想你目前擁有的幸福，每個人都擁有很多的。不要回想以前的不幸，
因為每個人也多多少少都有一些。——狄更斯

Reflect upon your present blessings, of which every
man has many, not on you past misfortunes,
of which all men have some.

*11,* *Never explain yourself to anyone.*
*Because the person who likes you doesn't*
*need it, and the person who dislikes you*
*won't believe it.*

Never explain yourself to anyone. Because the person who likes you doesn't need it, and the person who dislikes you won't believe it.

**永遠不需要為自己多做解釋。因為對於喜歡你的人不需要；而不喜歡你的人不會相信你。**

*Never explain yourself to anyone. Because the*
*person who likes you doesn't need it, and the*
*person who dislikes you won't believe it.*

*12, The course of true love never did run smooth.*

The course of true love never did run smooth.
**真愛之路永不會是平坦的。——莎士比亞，《仲夏夜之夢》**

*The course of true love never did run smooth.*

winter

## 13, *Love is blind and lovers cannot see the pretty follies that themselves commit.*

Love is blind and lovers cannot see the pretty follies that themselves commit.

**愛情是盲目的，戀人們看不到自己做的傻事。──莎士比亞，《威尼斯商人》**

*Love is blind and lovers cannot see the pretty follies that themselves commit.*

*14,* *Love's not love when it is mingled with regards that stands aloof from th'entire point.*

Love's not love when it is mingled with regards
that stands aloof from th'entire point.

**愛情裡面要是攙雜了和它本身無關的考量，那就不是愛情了。——莎士比亞，《李爾王》**

*Love's not love when it is mingled with regards*
*that stands aloof from th'entire point.*

winter

*15,* *Never lie to someone who trust you.*
*Never trust someone who lies to you.*

Never lie to someone who trust you. Never trust someone who lies to you.
不要欺騙任何相信你的人，不要相信任何欺騙你的人。

*Never lie to someone who trust you. Never trust someone who lies to you.*

*16.* *The most important thing is your self-respect. It doesn't matter what people think about you, but what you think about yourself.*

The most important thing is your self-respect. It doesn't matter what people think about you, but what you think about yourself.

**最重要的事物就是你的自尊。別人怎麼看你並不重要，重點是你怎麼看你自己。**

**——R. H. 阿普拉納爾普（美國發明家）**

*The most important thing is your self-respect. It doesn't matter what people think about you, but what you think about yourself.*

*17, It is well worth of falling love in someone, even can keep up with the unavoidable damage.*

It is well worth of falling love in someone, even can keep up
with the unavoidable damage.

愛上一個人的時候，一切都那麼值得，包括不可避免的傷害。

*It is well worth of falling love in someone,*
*even can keep up with the unavoidable damage.*

*18, If you just set out to be liked, you would be prepared to compromise on anything at anytime, and you would achieve nothing.*

If you just set out to be liked, you would be prepared to compromise on anything at anytime, and you would achieve nothing.

如果你只是想受歡迎，就要隨時準備好做出妥協，而你將因此一事無成。
——柴契爾夫人

*If you just set out to be liked, you would be prepared to compromise on anything at anytime, and you would achieve nothing.*

*19, Love helps us stay calm and serene even when things are tough.*

Love helps us stay calm and serene even when things are tough.

**愛幫助我們在艱難時刻保持沉著、平靜。**

*Love helps us stay calm and serene even when things are tough.*

華麗的探險

*20,* *Do not speak of your happiness to one less fortunate than yourself.*

Do not speak of your happiness to one less fortunate than yourself.
不要向不如你幸福的人訴說你的幸福。 ——普魯塔克（希臘羅馬作家）

*Do not speak of your happiness to one less fortunate than yourself.*

*21, In prosperity our friends know us; in adversity we know our friends.*

In prosperity our friends know us; in adversity we know our friends.

**在順境中，我們結交了朋友；在逆境中，我們瞭解了朋友。**——J. C. 柯林斯（英國評論家）

*In prosperity our friends know us; in adversity we know our friends.*

*22, Friendship is like money, easier made than kept.*

Friendship is like money, easier made than kept.
友誼如金錢一般，容易得到卻不易保持。——塞繆爾·巴特勒（英國作家）

*Friendship is like money, easier made than kept.*

*23,* *All happy families are like one another; each unhappy family is unhappy in it's own way.*

All happy families are like one another;
each unhappy family is unhappy in it's own way.

**幸福的家庭都是相似的；不幸的家庭各有各的不幸。——托爾斯泰**

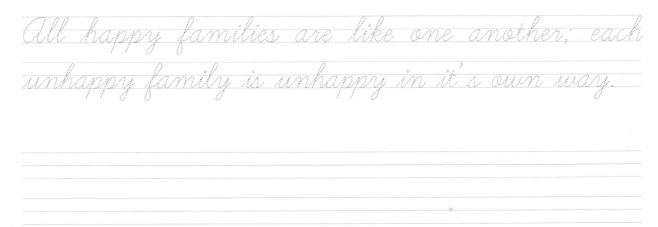

*24. Life is like an onion: you peel it off one layer at a time, and sometimes you weep.*

Life is like an onion: you peel it off
one layer at a time, and sometimes you weep.

**生活就像顆洋蔥：你只能一次剝開一層，有時還會流淚。──卡爾‧桑德伯格（美國詩人）**

*Life is like an onion: you peel it off one layer
at a time, and sometimes you weep.*

*25,* *Weep no more, no sigh, nor groan.*
*Sorrow calls no time that's gone.*

Weep no more, no sigh, nor groan. Sorrow calls no time that's gone.
**別哭泣，別嘆息，別呻吟；悲傷喚不回流逝的時光。──J. 弗萊契（英國劇作家）**

*Weep no more, no more, no sigh, nor groan. Sorrow calls*
*no time that's gone.*

*26,* *If you do not think about the future,*
*you cannot have one.*

If you do not think about the future, you cannot have one.

**如果你沒考慮過未來，那麼你就無法擁有未來。——約翰·高爾斯華綏（英國作家）**

If you do not think about the future, you cannot
have one.

winter

*27, Fix your eyes forward on what you can do, not back on what you cannot change.*

Fix your eyes forward on what you can do, not back on what you cannot change.

往前注視你能做的事，不要往後看你不能改變的事實。

——湯姆·克蘭西（美國小說家）

*Fix your eyes forward on what you can do, not*
*back on what you cannot change.*

28, *Against ill chances men are ever marry, but heaviness foreruns the good event.*

Against ill chances men are ever marry, but heaviness foreruns the good event.
樂極常生悲，而沉重的心情往往是吉兆。——莎士比亞，《亨利四世》

*Against ill chances men are ever marry, but heaviness foreruns the good event.*

## 29, *Praising what is lost makes the remembrance dear.*

Praising what is lost makes the remembrance dear.
**讚美那已經失去的，會使它在回憶中顯得格外可愛。**
——莎士比亞，《皆大歡喜》

*Praising what is lost makes the remembrance*

*dear.*

*30, The happiest of people don't necessarily have the best of everything.*

**The happiest of people don't necessarily have the best of everything.**
世界上最快樂的人，未必擁有最好的一切。

*The happiest of people don't necessarily have the best of everything.*

*31, There comes a special moment in everyone's life; a moment for which that person was born.*

There comes a special moment in everyone's life;
a moment for which that person was born.

**每個人在生命中都會遇到一個特別的時刻；一個完全適合他的時刻。——邱吉爾**

There comes a special moment in everyone's life;
a moment for which that person was born.

*32,* *A joke never gains an enemy but often loses a friend.*

A joke never gains an enemy but often loses a friend.

**開玩笑往往不能化敵為友，有時反而會失去朋友。**

*A joke never gains an enemy but often loses a friend.*

*33,* Whether happiness and sorrow in life would finally become memories. Why not face them with smile.

Whether happiness and sorrow in life would finally become memories.
Why not face them with smile.

**一生中無論快樂與悲傷，最終都將成為回憶，不妨微笑以對。**

Whether happiness and sorrow in life would
finally become memories. Why not face them
with smile.

華麗的探險

*34,* Remember, always learn to admit your mistakes that you've done, before somebody else exaggerates the story.

Remember, always learn to admit your mistakes that you've done, before somebody else exaggerates the story.

記住，一定要學會在別人添油加醋之前，承認自己所犯的錯誤。

Remember, always learn to admit your mistakes that you've done, before somebody else exaggerates the story.

*35,* *Don't try so hard, the best things come when you least expect them to.*

Don't try so hard, the best things come when you least expect them to.

**不要急，最好的事總在不經意的時候出現。**

*Don't try so hard, the best things come when you least expect them to.*

*36,* However mean your life is, meet it and live it; do not shun it and call it hard names.

However mean your life is, meet it and live it; do not shun it and call it hard names.
**不論你的人生如何悲涼，你都要面對它，好好地過，
不要躲避它，更別用惡言咒詛它。——亨利·大衛·梭羅（美國作家）**

However mean your life is, meet it and live it;
do not shun it and call it hard names.

*37,* *If you love someone, set them free.*
*If they come back they're yours; if they*
*don't they never were.*

If you love someone, set them free. If they come back they're yours;
if they don't they never were.

你若愛一個人就讓他走。他若回來，代表他是你的；
若他沒回來，他從來就不是。——理查・巴哈（美國作家）

*If you love someone, set them free. If they come*
*back they're yours; if they don't they never*
*were.*

*38.* *As selfishness and complaint cloud the mind, so love with its joy clears and sharpens the vision.*

As selfishness and complaint cloud the mind, so love with its joy clears and sharpens the vision.

自私和抱怨使心靈陰暗，愉快的愛則使視野明朗開闊。——海倫‧凱勒

*As selfishness and complaint cloud the mind, so love with its joy clears and sharpens the vision.*

39. *Life is a flower, and love is the honey of the flower.*

Life is a flower, and love is the honey of the flower.
**人生如花朵，愛便是那花蜜。——雨果（法國作家）**

*Life is a flower, and love is the honey of the flower.*

# 40, *If winter comes, can spring be far behind?*

If winter comes, can spring be far behind?

**冬天來了，春天還會遠嗎？──雪萊（英國詩人）**

*If winter comes, can spring be far behind?*

*Spring*

# 春 季

**讓心綻放，自在愉悅**

全新這一季
希望甜蜜地盛開了
深深吸一口最恬淨的清爽
然後，把一切交給微笑

## *1, Do not, for one repulse, give up the purpose that you resolved to effect.*

Do not, for one repulse, give up the purpose that you resolved to effect.

**不要因為一次的失敗，就放棄你原來決心想達到的目的。——莎士比亞**

華 麗 的 探 險

*2, Difficulties are meant to rouse, not discourage. The human spirit is to grow strong by conflict.*

Difficulties are meant to rouse, not discourage.
The human spirit is to grow strong by conflict.

**困難是用來激勵人心，而非使人氣餒的。人的心靈將因衝突而成長茁壯。**
**——威廉・強尼（神學家）**

## 3. *A great poem is a fountain forever overflowing with the waters of wisdom and delight.*

A great poem is a fountain forever overflowing with the waters of wisdom and delight.

**一首偉大的詩猶如一座噴泉，不斷地噴出智慧和快樂的泉水。——雪萊（英國詩人）**

A great poem is a fountain forever overflowing with the waters of wisdom and delight.

華麗的探險

# 4. *I have decided to be happy, because it is good for my health.*

I have decided to be happy, because it is good for my health.

**我已經決定了，要做個快樂的人，因為這有益我的健康。——伏爾泰**

*I have decided to be happy, because it is good for my*
*my health.*

5. *Praise is like sunlight to the human spirit, we cannot flower and grow without it.*

Praise is like sunlight to the human spirit, we cannot flower and grow without it.
對於人的心靈，讚揚就像陽光一樣，沒有它我們便不能開花生長。
——格雷安・葛林（英國作家）

*Praise is like sunlight to the human spirit, we cannot flower and grow without it.*

華麗的探險

55

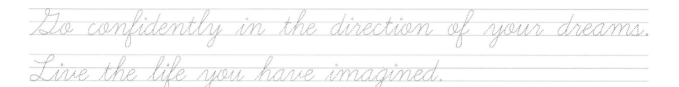

*6, Go confidently in the direction of your dreams. Live the life you have imagined.*

Go confidently in the direction of your dreams. Live the life you have imagined.

**帶著自信往你夢想的方向前進，過你所想像的生活。──亨利・大衛・梭羅（美國作家）**

Go confidently in the direction of your dreams.
Live the life you have imagined.

*7, The only place where your dream becomes impossible is in your own thinking.*

The only place where your dream becomes impossible is in your own thinking.
**唯一讓你的夢想變得不可能之處，就在你自己的想法中。——羅伯特・舒勒（美國牧師）**

The only place where your dream becomes impossible is in your own thinking.

華麗的探險

*8. The great thing in the world is not so much where we stand as in what direction we are moving.*

The great thing in the world is not so much where we stand
as in what direction we are moving.

**這個世界的美好之處，不在於我們的位置，而是我們正在往哪個方向移動。**

**──O. W. 霍姆斯（美國醫生）**

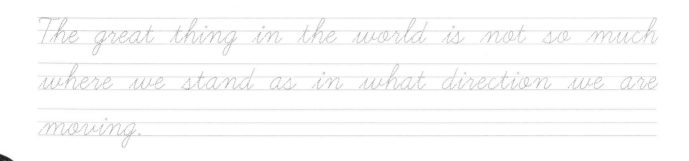

*9, Visualize this thing that you want, see it, feel it, believe in it. Make your mental blue print, and begin to build.*

Visualize this thing that you want, see it, feel it, believe in it.
Make your mental blue print, and begin to build.

想像你所想要的，看著它、感受它、相信它。在心裡畫一幅藍圖，然後開始打造它。

——羅伯特‧柯里爾（美國作家）

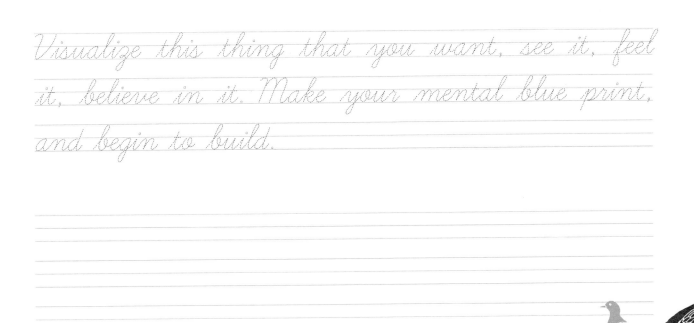

*Visualize this thing that you want, see it, feel it, believe in it. Make your mental blue print, and begin to build.*

*10, Today is life – the only life you are sure of. Make the most of today. Get interested in something. Shake yourself awake.*

Today is life – the only life you are sure of. Make the most of today.
Get interested in something. Shake yourself awake.

今天就是人生——你唯一可以確定的人生。充分利用今天，讓自己對某事感興趣，把自己搖醒。
——戴爾·卡內基（美國人際關係學大師）

*Today is life – the only life you are sure of. Make the most of today. Get interested in something. Shake yourself awake.*

*11, If you are working on something exciting that you really care about, you don't have to be pushed. The vision pulls you.*

If you are working on something exciting that you really care about,
you don't have to be pushed. The vision pulls you.

**如果你正致力於令人興奮而且是你真正關心的事，不需被催促，願景會牽引著你。——賈伯斯**

If you are working on something exciting that
you really care about, you don't have to be
pushed. The vision pulls you.

華麗的探險

## 12, *Three grand essentials to happiness in this life are something to do, something to love, and something to hope for.*

Three grand essentials to happiness in this life are something to do, something to love, and something to hope for.

**快樂人生的三個必要元素是，擁有要做的事、熱愛的事，以及盼望的事。**
——約瑟夫・艾迪生（英國散文家）

*Three grand essentials to happiness in this life are something to do, something to love, and something to hope for.*

# 13, Logic will get you from A to B. Imagination will take you everywhere.

Logic will get you from A to B. Imagination will take you everywhere.

**邏輯可以將你由A點帶到B點，想像則可以帶你到任何地方。——愛因斯坦**

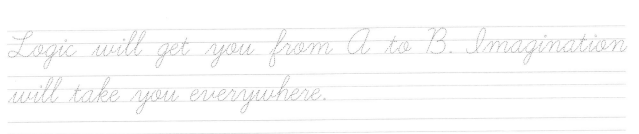

華麗的探險

*14, All love is sweet, given or returned. Common as light is loved, and its familiar voice wearies not ever.*

All love is sweet, given or returned. Common as light is loved,
and its familiar voice wearies not ever.

**所有的愛都是甜蜜的，不論是給予或回報。愛就如同陽光普照，
它那熟悉的嗓音永遠不會消沉。──雪萊（英國詩人）**

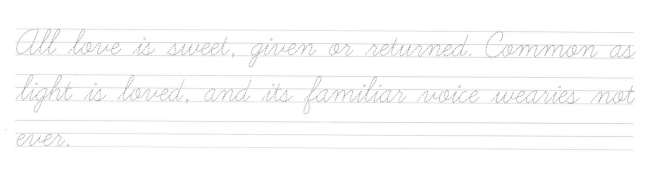

*15, Men are April when they woo, December when they wed; maids are May when they are maids, but the sky changes when they are wives.*

Men are April when they woo, December when they wed; maids are May when they are maids, but the sky changes when they are wives.

男人求婚時像四月天，婚後像十二月天；女人在少女時像五月天，為人妻後就變天。——莎士比亞

*Men are April when they woo, December when they wed; maids are May when they are maids, but the sky changes when they are wives.*

*16, Love should be a tree whose roots are deep in the earth, but whose branches extend into heaven.*

Love should be a tree whose roots are deep in the earth, but whose branches extend into heaven.

愛情應該如同一棵樹，深深紮根在泥土中，而它長起的枝條則要伸展於廣闊的天空。
——伯特蘭・羅素

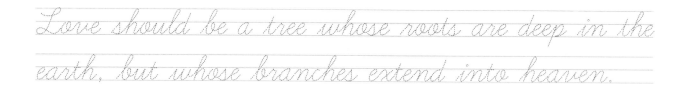

**17.** *New love is the brightest, and long love is the greatest, but revived love is the tenderest thing known on earth.*

New love is the brightest, and long love is the greatest,
but revived love is the tenderest thing known on earth.

**新生的愛情最為耀眼，長久的愛情最為偉大，而復甦的愛情則是世界上最溫柔之物。**
**——湯瑪斯·哈代**

New love is the brightest, and long love is the
greatest, but revived love is the tenderest thing
known on earth.

# 18, *There's nothing half so sweet in life as love's young dream.*

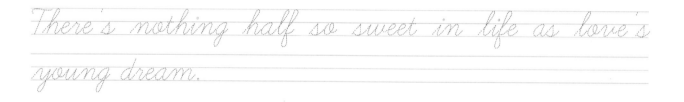

There's nothing half so sweet in life as love's young dream.

**生命中沒有任何東西像初戀的夢那樣甜美。——湯瑪斯·莫爾**

There's nothing half so sweet in life as love's young dream.

**19.** *Those who bring sunshine to the lives of others cannot keep it from themselves.*

Those who bring sunshine to the lives of others cannot keep it from themselves.

凡是為他人生命帶來陽光的人，自己也必定會沐浴在陽光下。——J. M. 巴里

*Those who bring sunshine to the lives of others cannot keep it from themselves.*

華麗的探險

# 20, *Differences of habit and language are nothing at all if our aims are identical and our hearts are open.*

Differences of habit and language are nothing at all if our aims are identical and our hearts are open.

只要目標相同，心胸開闊，習慣與語言的差異不足為慮。——J. K. 羅琳

## 21, *Making someone happy is perhaps the humblest way of approaching happiness.*

Making someone happy is perhaps the humblest way of approaching happiness.

**逗人開心，也許是獲取快樂最簡單的方法。——安東尼奧・卡勒（西班牙詩人）**

Making someone happy is perhaps the humblest way of approaching happiness.

華麗的探險

**22,** *You can turn painful situations around through laughter. If you can find humor in anything, even poverty, you can survive it.*

You can turn painful situations around through laughter.
If you can find humor in anything, even poverty, you can survive it.

透過歡笑，你可以扭轉痛苦的情境，如果你能在所有事物中找到幽默感，即便遭逢窮困，你也有辦法生存。
——比爾·寇斯比（美國演員）

*You can turn painful situations around through*
*laughter. If you can find humor in anything,*
*even poverty, you can survive it.*

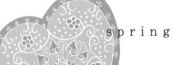

*23, Iron rusts from disuse, stagnant water loses its purity and in cold weather becomes frozen; even so does inaction sap the vigor of the mind.*

Iron rusts from disuse, stagnant water loses its purity and in cold weather becomes frozen; even so does inaction sap the vigor of the mind.

鐵因閒置而生鏽，不流動的水則失去純淨並在寒冷時結凍。同樣地，滯而不前也將削弱心智的力量。——達文西

*Iron rusts from disuse, stagnant water loses its purity and in cold weather becomes frozen; even so does inaction sap the vigor of the mind.*

華麗的探險

## 24. *Think of yourself as on the threshold of unparalleled success. A whole clear, glorious life lies before you. Achieve!*

Think of yourself as on the threshold of unparalleled success.
A whole clear, glorious life lies before you. Achieve!

想像自己就在空前的成功邊緣，一個全然清楚、輝煌的人生在前方等著你。去實現它！
——安德魯・卡內基（工業家）

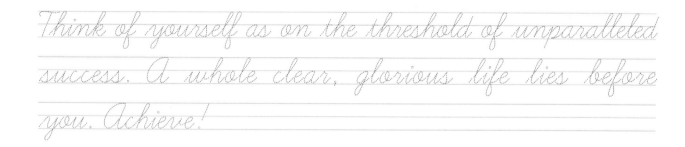

*25, Never stop smiling, not even when you are sad, someone might fall in love with your smile.*

Never stop smiling, not even when you are sad,
someone might fall in love with your smile.

**即使難過的時候，也永遠都不要停止微笑，說不定有人會因為你的笑容而愛上你。──馬奎斯**

*Never stop smiling, not even when you are sad,*

*someone might fall in love with your smile.*

華 麗 的 探 險

## 26, *We may pass violets looking for roses. We may pass contentment looking for victory.*

We may pass violets looking for roses. We may pass contentment looking for victory.
**我們可能在尋找玫瑰時錯失紫羅蘭，也可能在追尋成功時錯失快樂。**
——伯納德・威廉士（哲學家）

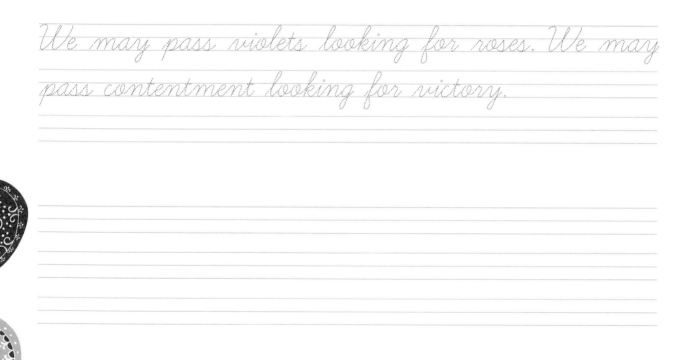

*27, The very first condition of lasting happiness is that a life should be full of purpose, aiming at something outside self.*

The very first condition of lasting happiness is that a life should be full of purpose, aiming at something outside self.

維持快樂的第一要素，是人生應該充滿目的，把目標放在自身以外的事物。

——休・布萊克（神學家）

The very first condition of lasting happiness is
that a life should be full of purpose, aiming at
something outside self.

華 麗 的 探 險

*28, We find that true happiness comes in seeking other things, in the manifold activities of life, in the healthful outgoing of all human powers.*

We find that true happiness comes in seeking other things, in the manifold activities of life, in the healthful outgoing of all human powers.

真正的快樂來自追求其他事物，追求人生中的各式活動，追求所有人類潛能的健康釋放。
——休·布萊克（神學家）

We find that true happiness comes in seeking
other things, in the manifold activities of life, in
the healthful outgoing of all human powers.

**29,** *The life force is vigorous. The delight that accompanies it counterbalances all the pains and hardships that confront men.*

The life force is vigorous. The delight that accompanies it counterbalances all the pains and hardships that confront men.

人生充滿活力，所伴隨的快樂抵消了所面臨的一切痛楚與困境。——毛姆

*The life force is vigorous. The delight that accompanies it counterbalances all the pains and hardships that confront men.*

華麗的探險

# 30, There will always be a frontier where there is an open mind and a willing hand.

There will always be a frontier where there is an open mind and a willing hand.
敞開的心胸加上願意行動，就永遠能發現新天地。——查理斯·凱特林（發明家）

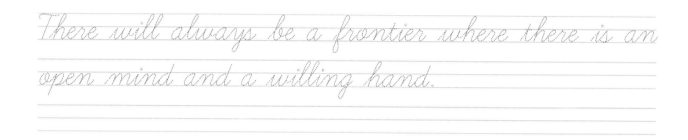

**31,** *Sooner or later, a man, if he is wise, discovers that life is a mixture of good days and bad, victory and defeat, give and take.*

Sooner or later, a man, if he is wise, discovers that life is a mixture of good days and bad, victory and defeat, give and take.

如果一個人有智慧，他遲早會發現，人生總是摻雜著好日子與壞日子、
勝利與失敗，以及施與受。——威佛德・彼得森（美國作家）

Sooner or later, a man, if he is wise, discovers
that life is a mixture of good days and bad,
victory and defeat, give and take.

華麗的探險

*32, Life never becomes a habit to me. It's always a marvel.*

Life never becomes a habit to me. It's always a marvel.

**我的人生絕不會成為習慣，它永遠充滿驚喜。——凱薩琳・曼斯菲爾德（英國作家）**

*Life never becomes a habit to me. It's always a marvel.*

33, *The growth of wisdom may be gauged exactly by the diminution of ill temper.*

The growth of wisdom may be gauged exactly by the diminution of ill temper.

乖戾脾氣的消失，可以精準反映出智慧的增長。——尼采

The growth of wisdom may be gauged exactly by the diminution of ill temper.

華麗的探險

## 34, *Good thoughts bear good fruit, bad thoughts bear bad fruit – and man is his own gardener.*

Good thoughts bear good fruit, bad thoughts bear bad fruit–
and man is his own gardener.

**好的想法產生好的果實，壞的想法產生壞的果實**
**──人們都是自身命運的栽種者。──詹姆士・艾倫（英國作家）**

## 35, Change, like sunshine, can be a friend or a foe, a blessing or a curse, a dawn or a dusk.

Change, like sunshine, can be a friend or a foe, a blessing or a curse, a dawn or a dusk.
改變如同陽光，它可以是朋友或敵人，是祝福或是詛咒，是黎明或是黃昏。
—— W. A. 沃德（美國學者）

華 麗 的 探 險

*36,* *Happiness is like a butterfly which, when pursued, is always beyond our grasp, but, if you will sit down quietly, may alight upon you.*

Happiness is like a butterfly which, when pursued, is always beyond our grasp, but, if you will sit down quietly, may alight upon you.

**快樂猶如一隻蝴蝶，被追求時永遠抓不到，但如果你安靜地坐下，它就會棲息在你身上。**
**——納撒尼爾・霍桑（美國作家）**

*Happiness is like a butterfly which, when pursued,*
*is always beyond our grasp, but, if you will sit*
*down quietly, may alight upon you.*

*37,* They always say time changes things, but you actually have to change them yourself.

They always say time changes things, but you actually have to change them yourself.
人們總說某些事會隨時間改變，但事實上，你必須自己改變它們。——安迪·沃荷

華麗的探險

*38,* *You may never know what results come of your action, but if you do nothing there will be no result.*

You may never know what results come of your action,
but if you do nothing there will be no result.

**你可能永遠不知道你的行為能帶來什麼結果，但沒有行動就不會有結果。——甘地**

*You may never know what results come of your action, but if you do nothing there will be no result.*

spring

88

**39,** *There is only one corner of the universe you can be certain of improving, and that's your own self.*

There is only one corner of the universe you can be certain of improving, and that's your own self.

這個世界唯有一個地方是你確定可以改進的，那就是你自己。——赫胥黎

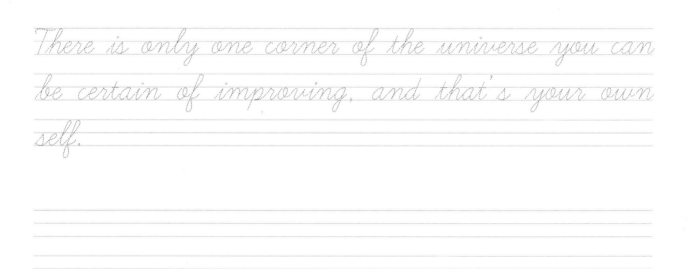

華麗的探險

# 40, When a person really desires something, all the universe conspires to help that person to realize his dream.

When a person really desires something, all the universe conspires
to help that person to realize his dream.

當一個人真的渴望某樣事物，全宇宙都會協助他實現夢想。——保羅·科爾賀

When a person really desires something, all the universe conspires to help that person to realize his dream.

*41, No matter how many times you change yourself, people will always find something bad to point their fingers at you.*

No matter how many times you change yourself, people will always find something bad to point their fingers at you.

**無論你改變自己多少次，人們總能找到指責你的地方。**

No matter how many times you change yourself, people will always find something bad to point their fingers at you.

華麗的探險

*42, You've got to get up every morning with determination if you're going to go to bed with satisfaction.*

You've got to get up every morning with determination if you're
going to go to bed with satisfaction.

**如果你想要心滿意足地入睡，早上就要帶著決心起床！**
**——G. H. 羅里梅（美國作家）**

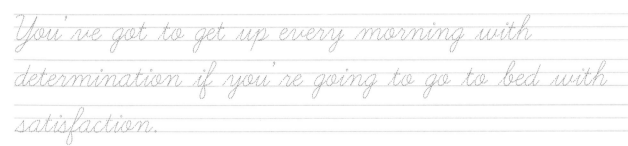

**43,** *Try not to become a man of success, but rather try to become a man of value.*

Try not to become a man of success, but rather try to become a man of value.

**別想去做個成功的人，要努力成為一個有價值的人。——愛因斯坦**

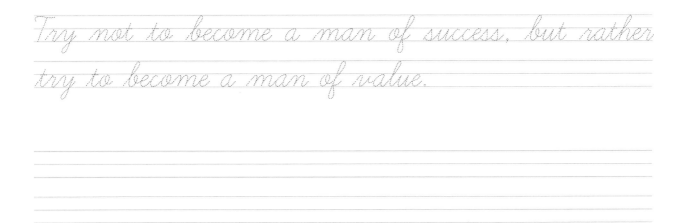

# 44, Really great people make you feel that, you, too, can become great.

Really great people make you feel that, you, too, can become great.

**真正偉大的人，會讓你感覺到自己也能變得偉大。──馬克・吐溫**

Really great people make you feel that, you, too, can become great.

spring

*45, The only limit to our realization of tomorrow will be our doubts of today.*

The only limit to our realization of tomorrow will be our doubts of today.

**實現明日理想的唯一障礙，是今日的疑慮。——富蘭克林·羅斯福**

*46, Believe that you have it, and you have it.*

Believe that you have it, and you have it.

相信你擁有，你就能真的擁有。

Believe that you have it, and you have it.

*Summary*

# 夏季

## 熱力豔陽．擁抱燦爛

夢想打包好滿滿活力
乘著勇氣之舟出發
航向未定，也不知歸期
唯有熱情是永恆

*1,* *Appreciation is a wonderful thing; it makes what is excellent in others belong to us as well.*

Appreciation is a wonderful thing; it makes what is excellent in others belong to us as well.

**欣賞是一件很美好的事;它讓別人的優點也成為我們自己的。——伏爾泰**

Appreciation is a wonderful thing; it makes what is excellent in others belong to us as well.

*2.* *These little thoughts are the rustle of leaves ; they have their whisper of joy in my mind.*

These little thoughts are the rustle of leaves ; they have their whisper of joy in my mind.

**這些瑣碎的想法，是樹葉間颯颯的風聲；它們喜悅的細語，留在我的心底。──泰戈爾**

These little thoughts are the rustle of leaves ; they have their whisper of joy in my mind.

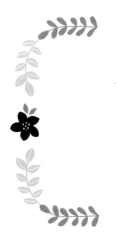

3, *The bird wishes it were a cloud ;*
*the cloud wishes it were a bird.*

The bird wishes it were a cloud ; the cloud wishes it were a bird.
鳥兒希望成為一朵白雲，白雲卻希望成為一隻飛鳥。——泰戈爾

華麗的探險

4, *Youth is not a time of life; it is a state of mind.*

Youth is not a time of life; it is a state of mind.

**青春不是生命的一段時期，而是一種心智的狀態。——塞繆爾‧厄爾曼**

5, *Rest is a good thing, but boredom is its brother.*

Rest is a good thing, but boredom is its brother.

**休息是件好事情，無聊卻是其兄弟。——伏爾泰**

*Rest is a good thing, but boredom is its brother.*

*6, To really understand a man we must judge him in misfortune.*

To really understand a man we must judge him in misfortune.
要真正瞭解一個人，須在他身處不幸的時候，方能判斷。──拿破崙

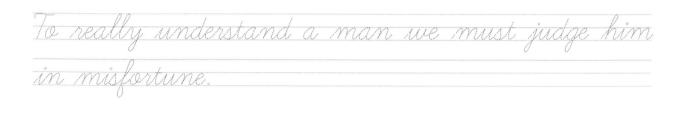

7. *I am a slow walker, but I never walk backwards.*

I am a slow walker, but I never walk backwards.

**我走得很慢,但我從來不會後退。——林肯**

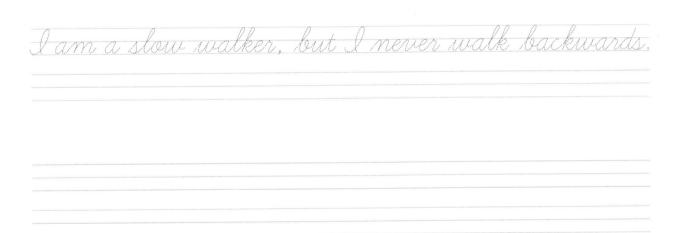

8, *Knowledge is a city to the building of which every human being brought a stone.*

Knowledge is a city to the building of which every human being brought a stone.
知識是一座城堡，每個人都應為它增添磚瓦。——愛默生

Knowledge is a city to the building of which every human being brought a stone.

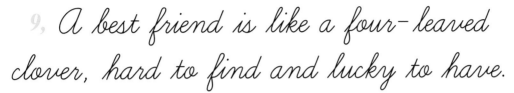

*9. A best friend is like a four-leaved clover, hard to find and lucky to have.*

A best friend is like a four-leaved clover, hard to find and lucky to have.

**好朋友就像幸運草一樣難找，能找到的人運氣真好！──愛爾蘭諺語**

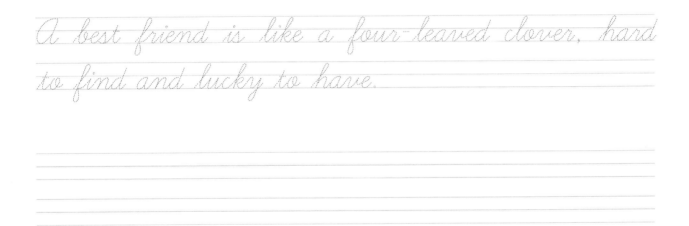

*10,* *It is not the strongest of the species that survive, nor the most intelligent, but the one most responsive to change.*

It is not the strongest of the species that survive, nor the most intelligent,
but the one most responsive to change.

生存下來的物種不是最強壯，也非最聰明的，而是最能夠適應改變的。

——達爾文（生物學家）

*It is not the strongest of the species that survive, nor the most intelligent, but the one most responsive to change.*

## 11, *Stressed is just desserts if you can reverse.*

Stressed is just desserts if you can reverse.

**壓力可以變成助力，只要你願意反向思考。**

*12,* *Human beings are not perfectible. They are improvable.*

Human beings are not perfectible. They are improvable.
**人無法十全十美，但可以愈來愈進步。——艾瑞克・塞弗泰德**

Human beings are not perfectible.

They are improvable.

## 13, *Anyone who has never made a mistake has never tried anything new.*

Anyone who has never made a mistake has never tried anything new.
從沒犯過錯的人，也絕不會有任何創新。——愛因斯坦

*14,* *If you would keep your secret from an enemy, tell it not to a friend.*

If you would keep your secret from an enemy, tell it not to a friend.
**如果不想讓敵人得知你的祕密，就不要把祕密告訴你的朋友。——班傑明・富蘭克林**

If you would keep your secret from an enemy,
tell it not to a friend.

*15,* *What we anticipate seldom occurs;*
*what we least expected generally happens.*

What we anticipate seldom occurs; what we least expected generally happens.

**我們所預料的事情很少發生；我們最始料未及的事情卻往往發生了。**

**——迪斯雷利（政治家）**

What we anticipate seldom occurs; what we least
expected generally happens.

華麗的探險

*16,* *Ordinary people merely think how they shall spend their time; a man of talent tries to use it.*

Ordinary people merely think how they shall spend their time;
a man of talent tries to use it.

普通人只想到如何度過時間，有才能的人則設法利用時間。——叔本華

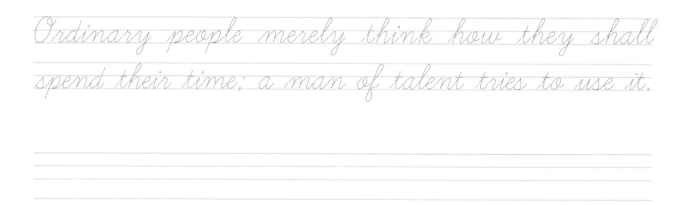

*17,* *Do you love life? Then do not squander time; for that's the stuff life is made of.*

Do you love life? Then do not squander time; for that's the stuff life is made of.

**你熱愛生活嗎？那麼，別浪費時間，因為生活是由時間組成的。**

**——班傑明‧富蘭克林**

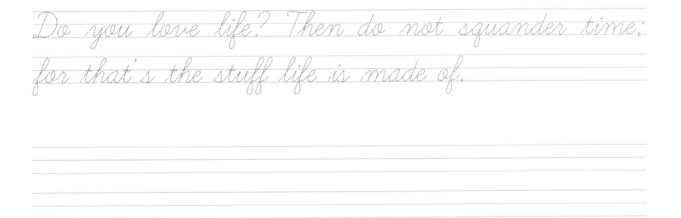

*18,* *It's not whether you get knocked down. It's whether you get up again.*

It's not whether you get knocked down. It's whether you get up again.

**你是否被擊倒並不是重點，重點在於你是否能再次站起來。——邱吉爾**

*19,* *Years may wrinkle the skin, but to give up enthusiasm wrinkles the soul.*

Years may wrinkle the skin, but to give up enthusiasm wrinkles the soul.

**歲月可使人的皮膚產生皺紋，但是放棄了熱情則使人心靈皺縮。——塞繆爾·厄爾曼**

華麗的探險

*20,* *To accomplish great things, we must not only act, but also dream, not only plan, but also believe.*

To accomplish great things, we must not only act, but also dream, not only plan, but also believe.

要成就大事，我們需要的不只是行動，還要去作夢，
不只是計畫，還要相信。——阿納托爾‧法郎士（法國小說家）

To accomplish great things, we must not only
act, but also dream, not only plan, but also
believe.

summer

*21,* *Success is not final, failure is not fatal: it is the courage to continue that counts.*

Success is not final, failure is not fatal: it is the courage to continue that counts.
**成功不是結局，失敗也不會致命，持續的勇氣才是重要的。──邱吉爾**

*22, Our greatest weakness lies in giving up. The most certain way to succeed is always to try just one more time.*

Our greatest weakness lies in giving up. The most certain way
to succeed is always to try just one more time.

**我們最大的弱點在於放棄，再多嘗試一次，永遠是最確定的成功之道。——愛迪生**

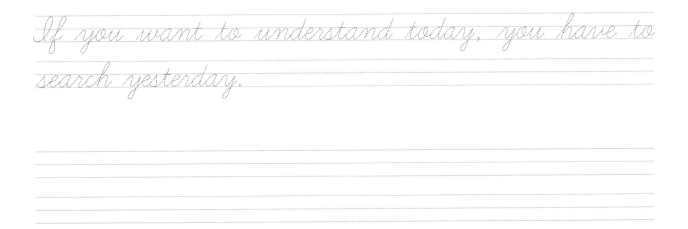

*23,* *If you want to understand today,*
*you have to search yesterday.*

If you want to understand today, you have to search yesterday.
**想要懂得今天，就必須研究昨天。——賽珍珠**

*If you want to understand today, you have to*
*search yesterday.*

## 24, *Being defeated is often a temporary condition. Giving up is what makes it permanent.*

Being defeated is often a temporary condition. Giving up is what makes it permanent.

被擊倒往往是一時的，放棄才會使它成為永恆。

——M. 莎凡特（美國人，世界智商最高的女性）

*Being defeated is often a temporary condition.*

*Giving up is what makes it permanent.*

*25,* *Flaming enthusiasm, backed up by horse sense and persistence, is the quality that most frequently makes for success.*

Flaming enthusiasm, backed up by horse sense and persistence,
is the quality that most frequently makes for success.

**強烈的熱忱，再以知識及堅持作為後盾，是成功者最常見的特質。**
**——戴爾·卡內基（美國人際關係學大師）**

Flaming enthusiasm, backed up by horse sense and
persistence, is the quality that most frequently
makes for success.

*26,* *I'm convinced that about half of what separates the successful entrepreneurs from the non-successful ones is pure perseverance.*

I'm convinced that about half of what separates the successful entrepreneurs from the non-successful ones is pure perseverance.

我確信，成功企業家與不成功企業家的區隔，大半在於純綷的堅持不懈。——賈伯斯

I'm convinced that about half of what separates the successful entrepreneurs from the non-successful ones is pure perseverance.

*27,* *We are made to persist. That's how we find out who we are.*

We are made to persist. That's how we find out who we are.

**我們是為了堅持而生，那是我們發現自己是誰的方式。——托比·沃夫（美國作家）**

We are made to persist. That's how we find out who we are.

*28,* *Fortune shows her power when there is no wise preparation for resisting her.*

Fortune shows her power when there is no wise preparation for resisting her.

若沒有向命運抗爭的明智準備，命運便會展示其威力。

*Fortune shows her power when there is no wise preparation for resisting her.*

*29,* *Many of the good things would never have happened if the bad events hadn't happened first.*

Many of the good things would never have happened
if the bad events hadn't happened first.

**若壞事沒有先發生，許多好的事情永遠不會發生。——蘇茜·歐曼（美國作家）**

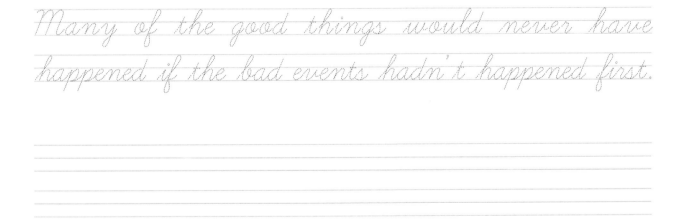

*30, It is not in the still calm of life, or in the repose of a pacific station, that great characters are formed.*

It is not in the still calm of life, or in the repose of a pacific station, that great characters are formed.

要形成偉大的人格特質，不是在平靜的生活，或無風的太平洋港灣裡。
——艾碧加・亞當斯（美國前第一夫人）

It is not in the still calm of life, or in the
repose of a pacific station, that great characters are
formed.

*31, When you come slam bang up against trouble, it never looks half as bad if you face up to it.*

When you come slam bang up against trouble, it never looks half as bad if you face up to it.

和難題對撞時，你如果面對它，就會發現它絕不及你所想的一半困難。

——約翰·韋恩（美國演員）

When you come slam bang up against trouble,

it never looks half as bad if you face up to it.

華麗的探險

*32,* *If you want something you've never had, you must be willing to do something you've never done.*

If you want something you've never had, you must be willing
to do something you've never done.
**你若想得到從未擁有的東西，就得願意做你從未做過的事。**
**——湯瑪斯‧傑佛遜（美國第三任總統）**

*If you want something you've never had, you must be willing to do something you've never done.*

*33,* *He that wrestles with us strengthens our nerves and sharpens our skill. Our antagonist is our helper.*

He that wrestles with us strengthens our nerves and sharpens our skill. Our antagonist is our helper.

**與我們對抗的人增加我們的勇氣,並提升我們的技術,**
**我們的對手就是來幫助我們的人。──艾德蒙・伯克(愛爾蘭政治家)**

He that wrestles with us strengthens our nerves and sharpens our skill. Our antagonist is our helper.

華麗的探險

*34,* *Courage is what it takes to stand up and speak; courage is also what it takes to sit down and listen.*

Courage is what it takes to stand up and speak;
courage is also what it takes to sit down and listen.
人不僅需要勇氣站起來說話，也需要勇氣坐下來傾聽。——邱吉爾

*35,* *The highest reward for man's toil is not what he gets for it, but what he becomes by it.*

The highest reward for man's toil is not what he gets for it, but what he becomes by it.

**努力的最大報酬不是你獲得什麼，而是你藉此成為什麼。**

——約翰‧拉斯金（藝術評論家）

*The highest reward for man's toil is not what he gets for it, but what he becomes by it.*

華 麗 的 探 險

*36, It is not because things are difficult that we do not dare, it is because we do not dare that they are difficult.*

It is not because things are difficult that we do not dare,
it is because we do not dare that they are difficult.
不是因為事情困難，而讓我們不敢做；是因為我們不敢做，才讓事情變得困難。
——塞內卡（哲學家）

It is not because things are difficult that we do
not dare, it is because we do not dare that they
are difficult.

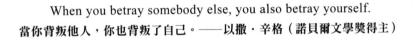 

*37.* *When you betray somebody else, you also betray yourself.*

When you betray somebody else, you also betray yourself.

**當你背叛他人，你也背叛了自己。——以撒·辛格（諾貝爾文學獎得主）**

*When you betray somebody else, you also betray yourself.*

華麗的探險

*38.* *What we do during our working hours determines what we have; what we do in our leisure hours determines what we are.*

What we do during our working hours determines what we have;
what we do in our leisure hours determines what we are.
**我們工作時做的事，決定我們擁有什麼；我們閒暇時做的事，決定我們成為哪種人。**
**——喬治·伊士曼（發明家）**

*What we do during our working hours determines*
*what we have; what we do in our leisure hours*
*determines what we are.*

*39,* *Things may come to those who wait, but only the things left by those who hustle.*

Things may come to those who wait, but only the things left by those who hustle.
等待之人或許可以獲得一些什麼，但那是積極行動之人留下的。──林肯

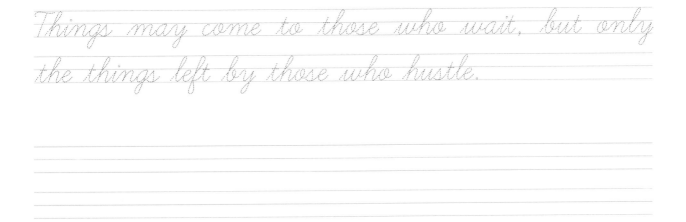

Things may come to those who wait, but only
the things left by those who hustle.

華 麗 的 探 險

*40,* *Right actions for the future are the best apologies for wrong ones in the past.*

Right actions for the future are the best apologies for wrong ones in the past.
對於過去所犯的錯，最好的道歉是在將來做正確的事。——泰倫‧愛德華茲（神學家）

*41,* *Idleness begets ennui, ennui the hypochondriac, and that a diseased body. No laborious person was ever yet hysterical.*

Idleness begets ennui, ennui the hypochondriac, and that a diseased body.
No laborious person was ever yet hysterical.

**閒怠使人無聊，無聊招致疑心病，而疑心病導致生病。努力工作的人不曾歇斯底里。**
**——湯瑪斯・傑佛遜（美國第三任總統）**

*Idleness begets ennui, ennui the hypochondriac, and that a diseased body. No laborious person was ever yet hysterical.*

華麗的探險

42, *Happiness is the only good. The time to be happy is now. The place to be happy is here. The way to be happy is to make others so.*

Happiness is the only good. The time to be happy is now.
The place to be happy is here. The way to be happy is to make others so.

快樂是唯一的好事。快樂的時候是現在,快樂的地方是這裡,快樂的方法是使他人快樂。
——羅伯特‧英格索(美國演說家)

*Happiness is the only good. The time to be happy is now. The place to be happy is here. The way to be happy is to make others so.*

*43,* *We win half the battle when we make up our minds to take the world as we find it, including the thorns.*

We win half the battle when we make up our minds to take the world as we find it, including the thorns.

**當我們下定決心面對世界上所有事物，包括荊棘難題在內，我們已經打贏了半場戰役。**

**——奧里森·馬登（美國成功學之父）**

We win half the battle when we make up our
minds to take the world as we find it, including
the thorns.

華麗的探險

*44, Nothing gives one person so much advantage over another as to remain always cool and unruffled under all circumstances.*

Nothing gives one person so much advantage over another as to remain always cool and unruffled under all circumstances.

在任何情況下永遠保持冷靜且不受影響，可以帶給一個人莫大的優勢。
——湯瑪斯·傑佛遜（美國第三任總統）

Nothing gives one person so much advantage over another as to remain always cool and unruffled under all circumstances.

## 45, *Kites rise highest against the wind, not with it.*

Kites rise highest against the wind, not with it.
**風箏逆著風飛得最高，而不是順著風。——邱吉爾**

**46,** *I'd rather be a failure at something I love than a success at something I hate.*

I'd rather be a failure at something I love than a success at something I hate.

我寧願做我愛做的事而失敗，也不要做我討厭的事而成功。——喬治·伯恩斯（美國喜劇演員）

*I'd rather be a failure at something I love than a success at something I hate.*

*Autumn*

# 秋季

### 緩下腳步，讓心沉澱

走得慢一點點
想得慢一點點
心情放慢一點點
再多給自己一點鼓勵，相信夢想

*1, Knowledge makes humble, ignorance makes proud.*

Knowledge makes humble, ignorance makes proud.
知識使人謙虛，無知使人驕傲。

*Knowledge makes humble, ignorance makes proud.*

*2,* *Reading makes a full man;  conference a ready man;  and writing an exact man.*

Reading makes a full man; conference a ready man; and writing an exact man.
**讀書使人充實，討論使人機敏，寫作使人嚴謹。──培根**

3. *Man can climb to the highest summit, but he cannot dwell there long.*

Man can climb to the highest summit, but he cannot dwell there long.

**人可以爬到最高峰，但無法在那兒久住。——蕭伯納（英國劇作家）**

*Man can climb to the highest summit, but he cannot dwell there long.*

*4. Most of the trouble in the world is caused by people wanting to be important.*

Most of the trouble in the world is caused by people wanting to be important.

世界上大部分的麻煩都是那些想成為大人物的人搞出來的。——T. S. 艾略特

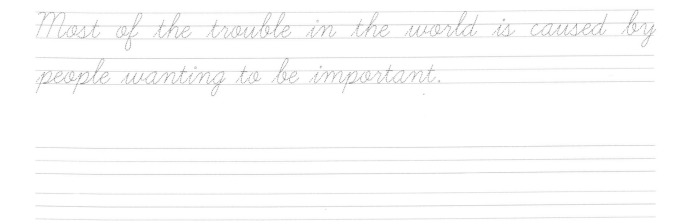

autumn

*5. Habit is habit, and not to be flung out of the window by any man, but coaxed downstairs a step a time.*

Habit is habit, and not to be flung out of the window by any man, but coaxed downstairs a step a time.

習慣就是習慣，誰也不能將其扔出窗外，只能一步一步地哄它下樓。——馬克・吐溫

Habit is habit, and not to be flung out of the window by any man, but coaxed downstairs a step a time.

華 麗 的 探 險

*6, The reasonable man adapts himself to the world; the unreasonable one persists in trying to adapt the world to himself.*

The reasonable man adapts himself to the world; the unreasonable one persists in trying to adapt the world to himself.

明白事理的人使自己適應世界，不明事理的人則堅持要世界適應自己。
——蕭伯納（英國劇作家）

*The reasonable man adapts himself to the world; the unreasonable one persists in trying to adapt the world to himself.*

*7. The jealous are troublesome to others, but a torment to themselves.*

The jealous are troublesome to others, but a torment to themselves.

**妒忌者對別人是個麻煩，對他們自己卻是折磨。──威廉·佩恩（英國哲學家）**

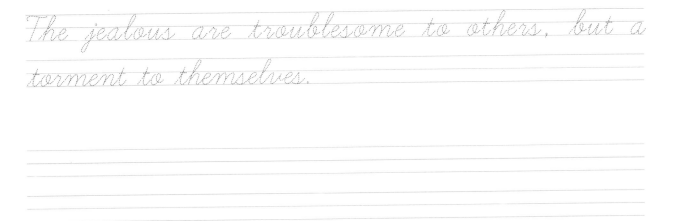

華麗的探險

*8. Don't waste life in doubts and fears.*

Don't waste life in doubts and fears.
不要把生命浪費於懷疑與恐懼中。——愛默生

*Don't waste life in doubts and fears.*

# 9, *Hope is the poor man's bread.*

Hope is the poor man's bread.
**希望是窮人的精神麵包。——喬治・赫伯特（英國詩人）**

*Hope is the poor man's bread.*

*10, There is a sufficiency in the world for man's need but not for man's greed.*

There is a sufficiency in the world for man's need but not for man's greed.

**這個世界能滿足人們的所有需求，但滿足不了貪欲。——甘地**

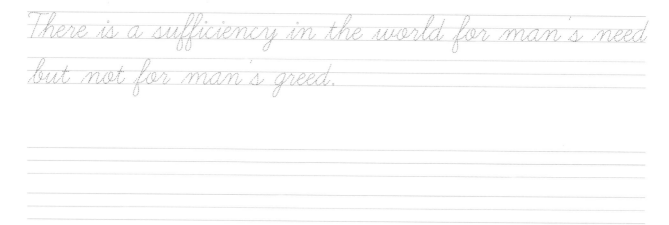

*11,* *We must accept finite disappointment,*
*but we must never lose infinite hope.*

We must accept finite disappointment, but we must never lose infinite hope.
**我們必須接受失望，因為它是有限的，但千萬不可失去希望，因為它是無窮的。**
——馬丁・路德・金恩

*12, The starting point of all achievement is desire.*

The starting point of all achievement is desire.

希望是所有成就的起點。——拿破倫・希爾（美國作家）

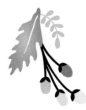

*The starting point of all achievement is desire.*

*13,* *It's not enough that we do our best;*
*sometimes we have to do what's required.*

It's not enough that we do our best; sometimes we have to do what's required.

**有時候，盡最大的努力還不夠，還得做到需要做的事。——邱吉爾**

華麗的探險

*14,* *A man who is never satisfied with himself and whom therefore nobody can please.*

A man who is never satisfied with himself and whom therefore nobody can please.
人要是從來不滿意自己，就不會有人能夠使他滿意。——歌德

*A man who is never satisfied with himself and whom therefore nobody can please.*

*15,* *All work and no play makes jack a dull boy.*

**All work and no play makes jack a dull boy.**
**只工作不娛樂，使人愚鈍。**

*All work and no play makes jack a dull boy.*

華麗的探險

*16, Come what come may, time and the hour runs through the roughest day.*

**Come what come may, time and the hour runs through the roughest day.**
**無論將發生什麼事，再多事的日子總也會過去的。——莎士比亞，《馬克白》**

*Come what come may, time and the hour runs through the roughest day.*

*17, A tree should grow taller, accept more brightness, then its root must be deeper and darker.*

A tree should grow taller, accept more brightness, then its root must be deeper and darker.

若一棵樹要長得更高，接受更多的光明，那麼它的根就必須更深入黑暗。——尼采

*A tree should grow taller, accept more brightness, then its root must be deeper and darker.*

*then its root must be deeper and darker.*

*18,* *The human spirit can handle much worse than we realize. It matters how you are going to finish.*

The human spirit can handle much worse than we realize.
It matters how you are going to finish.
人的心靈可以應付比我們所知更壞得多的事，重要的是你將如何走完。
——力克‧胡哲（澳洲勵志作家）

*The human spirit can handle much worse than*
*we realize. It matters how you are going to*
*finish.*

*19. In the confrontation between the stream and the rock, the stream always wins, not through strength but by perseverance.*

In the confrontation between the stream and the rock, the stream always wins, not through strength but by perseverance.

在溪流與岩石的對峙裡，溪流永遠勝利，不是藉由力量，而是經由堅持不懈。
——傑克森・小布朗（美國勵志作家）

*In the confrontation between the stream and the rock, the stream always wins, not through strength but by perseverance.*

*20,* *Some troubles are imaginary, but the suffering they cause is real.*

Some troubles are imaginary, but the suffering they cause is real.

**有些煩惱是我們想像出來的，但我們卻把它當成真的去承受。**

Some troubles are imaginary, but the suffering
they cause is real.

21, *Prosperity is not without many fears and disasters, adversity is not without comforts and hopes.*

Prosperity is not without many fears and disasters,
adversity is not without comforts and hopes.

**順境裡不盡然就沒有恐懼與不幸，而逆境裡也並非不存有慰藉與希望。──培根**

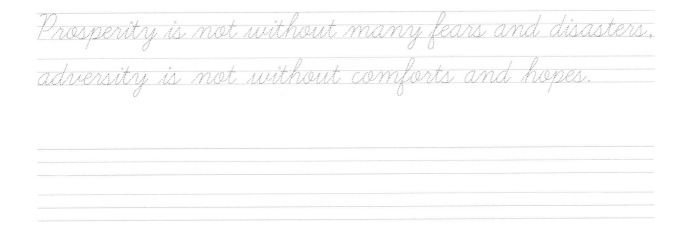

*22,* A man is not old as long as he is seeking something. A man is not old until regrets take the place of dreams.

A man is not old as long as he is seeking something. A man is not old until regrets take the place of dreams.

一個人只要還有所追求，他就沒有老。若他讓懊悔取代了夢想，他就老了。——約翰‧巴里摩

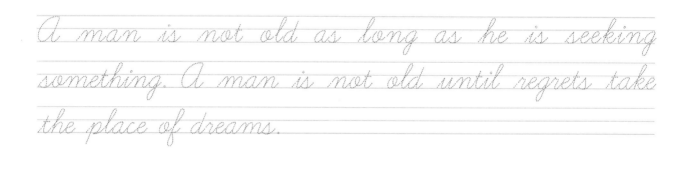

*23,* *A duty dodged is like a debt unpaid;*
*it is only deferred, and we must come*
*back and settle the account at last.*

A duty dodged is like a debt unpaid; it is only deferred,
and we must come back and settle the account at last.

**逃避的責任如同沒有還清的債務，它只是被延期，我們最終還是要回來結清債務。**

——約瑟夫・紐頓（美國牧師）

*24,* *Everything that is happening at this moment is a result of the choices you've made in the past.*

Everything that is happening at this moment is a result
of the choices you've made in the past.

**此刻所發生的所有事情，都是你過去選擇的結果。**
——狄帕克·約伯拉（印度心靈導師）

*Everything that is happening at this moment is*
*a result of the choices you've made in the past.*

*25.* When you complain, you make yourself a victim. Leave the situation, change the situation, or accept it. All else is madness.

When you complain, you make yourself a victim. Leave the situation, change the situation, or accept it. All else is madness.

當你抱怨時，你讓自己成了受害者。離開、改變或接受那個環境吧，其他的行為都是愚蠢的。
——艾克哈特・托勒（美國作家）

When you complain, you make yourself a victim. Leave the situation, change the situation, or accept it. All else is madness.

*26,* *There is nothing noble in being superior to your fellow man; true nobility is being superior to your former self.*

There is nothing noble in being superior to your fellow man; true nobility is being superior to your former self.

**超越別人不算優異，超越自己才是真正的非凡。──海明威**

*27, Never walk away from failure. On the contrary, study it carefully and imaginatively for its hidden assets.*

Never walk away from failure. On the contrary, study it carefully and imaginatively for its hidden assets.

**遇到失敗絕不要一走了之，相反地，要仔細且有想像力地研究它所隱藏的價值。**

**——麥克‧柯達（美國出版人）**

Never walk away from failure. On the contrary, study it carefully and imaginatively for its hidden assets.

*28, You can fail at what you don't want, so you might as well take a chance on doing what you love.*

You can fail at what you don't want, so you might as well
take a chance on doing what you love.

做你不想做的事，你可能會失敗，還不如冒個險，做你熱愛的事。──金凱瑞（美國演員）

*You can fail at what you don't want, so you
might as well take a chance on doing what you
love.*

*29, He who knows no hardships will know no hardihood. He who faces no calamity will need no courage.*

He who knows no hardships will know no hardihood. He who faces no calamity will need no courage.

**沒體驗過困苦的人不識堅毅，沒遇過災難的人則不需要勇氣。——哈利・弗斯迪克（美國牧師）**

He who knows no hardships will know no
hardihood. He who faces no calamity will need
no courage.

華麗的探險

*30.* *Prejudice is a burden that confuses the past, threatens the future and renders the present inaccessible.*

Prejudice is a burden that confuses the past, threatens the future and renders the present inaccessible.

偏見是一種負擔，它混淆過去，威脅未來，並讓我們無法掌握當下。

——瑪雅‧安哲羅（美國詩人）

*Prejudice is a burden that confuses the past, threatens the future and renders the present inaccessible.*

*31, There are two freedoms – the false, where a man is free to do what he likes; the true, where he is free to do what he ought.*

There are two freedoms – the false, where a man is free to do what he likes;
the true, where he is free to do what he ought.

**自由有兩種——假自由讓人做想做的事；真自由讓人做該做的事。—查理斯·金斯利（英國文學家）**

There are two freedoms – the false, where a man is free to do what he likes; the true, where he is free to do what he ought.

*32,* *In this world everything changes except good deeds and bad deeds; these follow you as the shadow follows the body.*

In this world everything changes except good deeds and bad deeds;
these follow you as the shadow follows the body.

世上所有事情都會改變，除了善行和惡行，它們如影隨形地跟著你。
——露絲·潘乃德（美國人類學家）

*In this world everything changes except good deeds and bad deeds; these follow you as the shadow follows the body.*

*33. Write your injuries in dust, your benefits in marble.*

Write your injuries in dust, your benefits in marble.

把你受的傷害寫在沙上，把你受的恩惠刻在大理石上。——班傑明‧富蘭克林

*Write your injuries in dust, your benefits in marble.*

華麗的探險

*34.* *Your living is determined not so much by what life brings to you as by the attitude you bring to life.*

Your living is determined not so much by what life brings to you as by the attitude you bring to life.

你的人生不是取決於生活帶給你什麼，而是你把何種態度帶至生活裡。——紀伯倫

Your living is determined not so much by what life brings to you as by the attitude you bring to life.

*35,* *The minute you start talking about what you're going to do if you lose, you have lost.*

The minute you start talking about what you're going to do if you lose, you have lost.
從你開始談論如果失敗了要怎麼辦的那一刻起，你已經失敗了。
——喬治·舒爾茲（美國政治家）

華麗的探險

36, *Do not go where the path may lead, go instead where there is no path and leave a trail.*

Do not go where the path may lead, go instead where there is no path and leave a trail.
別去道路通往的地方，往沒路的地方走，並且留下足跡。──愛默生

*Do not go where the path may lead, go instead where there is no path and leave a trail.*

*37, Happy is the man who is living by his hobby.*

Happy is the man who is living by his hobby.

**醉心於某種癖好的人是幸福的。——蕭伯納（英國劇作家）**

*Happy is the man who is living by his hobby.*

*38,* *The supreme happiness of life is the conviction that we are loved.*

**The supreme happiness of life is the conviction that we are loved.**
**生活中最極致的幸福是堅信有人愛著我們。──雨果（法國作家）**

*The supreme happiness of life is the conviction that we are loved.*

國家圖書館預行編目資料

華麗的探險：臨摹英文佳句，練字練心，探索
自我／薩莉亞編著. ──初版. ──臺北市：寶
瓶文化, 2016. 02
　面；　公分. ──（Enjoy；057）
中英對照
ISBN 978-986-406-047-4（平裝）
1. 習字範本　2. 英語

943. 98　　　　　　　　　　　　　105002096

Enjoy 057

華麗的探險──臨摹英文佳句，練字練心，探索自我

作者／薩莉亞
外文主編／簡伊玲

發行人／張寶琴
社長兼總編輯／朱亞君
主編／簡伊玲‧張純玲
編輯／丁慧瑋‧賴逸娟
美術主編／林慧雯
校對／丁慧瑋‧賴逸娟‧薩莉亞
業務經理／李婉婷　企劃專員／林歆婕
財務主任／歐素琪　業務專員／林裕翔
出版者／寶瓶文化事業股份有限公司
地址／台北市110信義區基隆路一段180號8樓
電話／(02) 27494988　傳真／(02) 27495072
郵政劃撥／19446403　寶瓶文化事業股份有限公司
印刷廠／世和印製企業有限公司
總經銷／大和書報圖書股份有限公司　電話／(02) 89902588
地址／新北市五股工業區五工五路2號　傳真／(02) 22997900
E-mail／aquarius@udngroup.com
版權所有‧翻印必究
法律顧問／理律法律事務所陳長文律師、蔣大中律師
如有破損或裝訂錯誤，請寄回本公司更換
著作完成日期／二〇一五年十二月
初版一刷日期／二〇一六年二月
初版二刷日期／二〇一六年二月二十二日
ISBN／978-986-406-047-4
定價／三四〇元
Copyright©2016 by Saliya
Published by Aquarius Publishing Co., Ltd.
All Rights Reserved
Printed in Taiwan.

感謝您熱心的為我們填寫，
對您的意見，我們會認真的加以參考，
希望寶瓶文化推出的每一本書，都能得到您的肯定與永遠的支持。

系列：Enjoy057　　**書名：華麗的探險——臨摹英文佳句，練字練心，探索自我**

1. 姓名：＿＿＿＿＿＿＿＿　　性別：□男　□女

2. 生日：＿＿＿年＿＿＿月＿＿＿日

3. 教育程度：□大學以上　□大學　□專科　□高中、高職　□高中職以下

4. 職業：＿＿＿＿＿＿＿＿

5. 聯絡地址：＿＿＿＿＿＿＿＿＿＿＿＿＿＿＿＿＿＿＿＿＿＿

　聯絡電話：＿＿＿＿＿＿＿＿　　手機：＿＿＿＿＿＿＿＿

6. E-mail信箱：＿＿＿＿＿＿＿＿＿＿＿＿＿＿＿＿

　　　　　□同意　□不同意　免費獲得寶瓶文化叢書訊息

7. 購買日期：＿＿＿年＿＿＿月＿＿＿日

8. 您得知本書的管道：□報紙／雜誌　□電視／電台　□親友介紹　□逛書店　□網路
　□傳單／海報　□廣告　□其他

9. 您在哪裡買到本書：□書店，店名＿＿＿＿＿＿　□劃撥　□現場活動　□贈書
　□網路購書，網站名稱：＿＿＿＿＿＿　□其他＿＿＿＿＿

10. 對本書的建議：（請填代號　1. 滿意　2. 尚可　3. 再改進，請提供意見）

　　內容：＿＿＿＿＿＿＿＿＿＿＿＿

　　封面：＿＿＿＿＿＿＿＿＿＿＿＿

　　編排：＿＿＿＿＿＿＿＿＿＿＿＿

　　其他：＿＿＿＿＿＿＿＿＿＿＿＿

　　綜合意見：＿＿＿＿＿＿＿＿＿＿＿＿＿＿＿＿＿＿＿＿＿＿

11. 希望我們未來出版哪一類的書籍：＿＿＿＿＿＿＿＿＿＿＿＿＿＿＿＿

讓文字與書寫的聲音大鳴大放
**寶瓶文化事業股份有限公司**

寶瓶文化事業股份有限公司　收

110台北市信義區基隆路一段180號8樓

8F,180 KEELUNG RD.,SEC.1,

TAIPEI.(110)TAIWAN R.O.C.

（請沿虛線對折後寄回，或傳真至02-27495072。謝謝）

輕鬆描，給自己或親愛的人祝福吧！

To:

*Today is life – the only life you are sure of.*

By

輕鬆描，給自己或親愛的人祝福吧！

To:

*I am a slow walker, but I never walk backwards.*

By

輕鬆描，給自己或親愛的人祝福吧！

To:

*You can fail at what you don't want, so you might as well take a chance on doing what you love.*

By

Today is life – the only life you are sure of.

今天就是人生──你唯一可以確定的人生。
　　　　　　　──戴爾・卡內基（美國人際關係學大師）

I am a slow walker, but I never walk backwards.

我走得很慢，但我從來不會後退。
　　　　　　　　　　──林肯

You can fail at what you don't want, so you might
as well take a chance on doing what you love.

做你不想做的事，你可能會失敗，還不如冒個險，做你熱愛的事。
　　　　　　　　　　──金凱瑞（美國演員）

To:

*If you love someone, set them free. If they come back they're yours; if they don't they never were.*

By

To:

*They always say time changes things, but you actually have to change them yourself.*

By

To:

*Love is blind and lovers cannot see the pretty follies that themselves commit.*

By

If you love someone, set them free. If they come back they're yours;
if they don't they never were.

你若愛一個人就讓他走。他若回來，代表他是你的；若他沒回來，他從來就不是。
——理查·巴哈（美國作家）

They always say time changes things, but you actually have to change them yourself.

人們總說某些事會隨時間改變，但事實上，你必須自己改變它們。
——安迪·沃荷

Love is blind and lovers cannot see the pretty follies that themselves commit.

愛情是盲目的，戀人們看不到自己做的傻事。
——莎士比亞，《威尼斯商人》

W²/²⁸